POSTERS OF THE
FIRST WORLD WAR

IWM holds over 20,000 posters in its collections, dating from the First World War to the present day. For more information visit iwm.org.uk

Published by IWM, Lambeth Road, London SE1 6HZ
iwm.org.uk

ISBN 978-1-904897-87-3
A catalogue record for this book is available from the British Library.
Printed and bound in the EU
Design by beckyhampson.co.uk

10 9 8 7 6 5 4 3 2 1

INTRODUCTION BY NIGEL STEEL
IMAGE SELECTION BY RICHARD SLOCOMBE

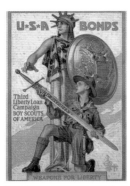
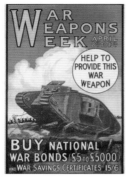
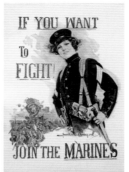
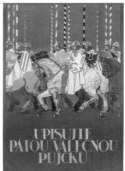
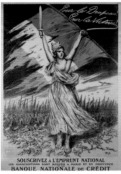
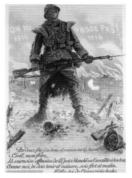
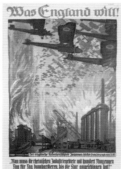
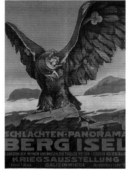
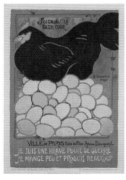
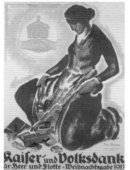
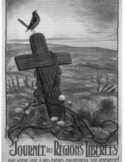
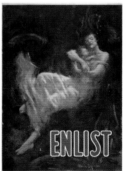
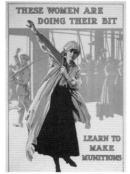
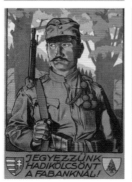
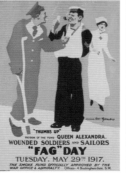
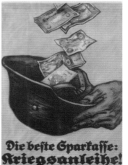

HEARTS AND MINDS
THE MASS APPEAL OF POSTERS IN THE FIRST WORLD WAR

Despite the enmity and hatred generated by the First World War, the warring nations all experienced a great deal in common. People suffered intense loss, homes were destroyed by bombing and fighting, and food ran short. But despite these terrible things, most of those that took part remained committed to the war until the very end. The civilians back home continued to believe in the justice of their cause as strongly as the men at the front.

One of the reasons for this was their careful manipulation by governments that needed everyone to believe their struggle was right and their sacrifices equally shared. To do this, civilian and military leaders had to find a vehicle for mass communication, something that both stirred the hearts and stimulated the minds of their nations. Not yet equipped with radio or cinema, let alone television, the medium they used with remarkable skill was the poster.

Across the years 1914 to 1918, no other form of popular appeal had such a profound effect on the lives of ordinary people as the poster. Posters were everywhere: in railway stations, in city centres, on buses and on walls, subliminally influencing people as they walked casually down the street. Each nation had its own distinct styles and designs. But their purpose was all the same – to bind people together, and to uphold their consent in the war.

This book includes only a relatively small selection of the thousands of First World War posters collected by the Imperial War Museum since its foundation in 1917. It is not a comprehensive account of how posters developed or steered global populations at times of crisis, but gives a feel for the dynamism and energy of this popular medium at possibly the zenith of its influence. It includes many well-known posters produced by the war's leading nations, comparing and contrasting national and international messages and aesthetic styles to show how the poster emerged as probably the world's most democratic art form.

The first concerted poster campaign was launched in Britain during September 1914 to maintain the numbers of men coming forward to enlist. Over 200,000 men had already joined up and the first posters produced by the new Parliamentary Recruiting Committee (PRC) presented only plain, factual calls to action. But, as the initial surge in recruits levelled off, something more dramatic was needed. The answer lay in pictorial posters.

The PRC had no experience of using popular media to launch such a wide appeal. For this, despite some initial reservations about its perceived vulgarity, they turned to the advertising industry. Towards the end of November 1914 new posters began to appear. Well designed, brightly coloured and highly emotive, they were commercially guided and began to sell complex ideas of duty and national service like soap or breakfast cereals.

By the end of 1915, the PRC had produced over 12 million posters using 164 distinct designs. Many were hard-hitting and powerful, stirring people's

consciences and probing their sense of moral integrity. But this approach proved the least successful. More popular were designs that evoked a sense of comradeship. As has often been the case for the British people, self-deprecating humour and a light touch proved more effective than moral blackmail. Smiling soldiers enjoying each other's company sold the war much better than a sense of shame.

These same values were shared across the British Empire. Men from all its countries were inspired by similar messages to join up to defend their way of life. But the posters, particularly from Australia, New Zealand, Canada and South Africa, were keen to emphasise the unique traits that already made their countries different. By identifying these soldiers with their own lands, posters helped promote a growing sense of national pride within the shared experience of the war.

In France, Germany and Austria-Hungary there was no need for the state to launch a call for new recruits. These countries all based their large armies on the principle of national service. Instead the need to shore up popular support for the war came as money and resources began to run short. Increasing numbers of posters began to appear from 1916 appealing for funds to support their respective war efforts, and consolidating widespread consent to the continuation of the struggle. Yet, although the various national campaigns shared many characteristics, each one was clearly distinct.

In Germany the message of the posters was direct and authoritarian, reflecting German society and its domination by the ruling Prussian elite. People expected to be told, not implored, and to obey, not just agree. The individualism of the liberal democracies of France and Britain were seen as weak and decadent, whereas from their commitment to the state the Germans drew strength and unity. Unable to raise money for their war economy through the international money markets, the German government was forced to launch a series of war loans, asking people to invest in the state to finance the war. Inspired by clever poster campaigns, Germany succeeded in covering 60 per cent of its war costs in this way.

A few years before the war, a new style of poster had emerged in Germany. Known as the 'object poster', it used arresting colours, a clear central product and a snappy, easily-understood punchline to bind the design tightly together. Instead of using the picture simply as an illustration, it became an integral part of the poster's overall aesthetic. Simple but powerful, the 'object poster' provided the template for many wartime images.

In Austria-Hungary too the emphasis was on the high quality of a poster's design. Tending towards the abstract and culturally refined, Austro-Hungarian posters often lacked passion and urgency. They did not generate the mass emotional appeals seen in British recruitment posters. Austria-Hungary had to be careful. It was a cosmopolitan assembly of many different ethnic groups. If campaigns appealed too strongly to any one of these by highlighting individual folk traditions or regional characteristics, they risked promoting latent desires for independence and autonomy. Although discernible in many Austro-Hungarian posters, these differences remained tightly controlled.

Instead, like Germany itself, Austro-Hungarian designs fell back on a romanticised sense of German culture. In both countries, using a palette of perceived German colours – brown, dark red and gold reflecting the widespread forests, wine harvests and the autumn fall – posters were dominated by images of medieval chivalry and Teutonic knights willing to make the ultimate blood sacrifice for the Fatherland. Swords were prominent, linking the distant past to the current reality of industrialised modern weapons, along with ancient dragon-like monsters, a deadly enemy to be slain on the battlefield.

In France it was all very different. Although it too fell back on its history and cultural heritage, its national poster campaigns were the antithesis of the militarism and authoritarianism of Germany and Austria-Hungary. France was a republic and proud of it. It claimed to have existed since the Revolution as an egalitarian society that cherished regional diversity. Being French was temperamental, not racial. People felt French because they shared values and a common past.

French posters adopted a more realistic style. Emotional impact was achieved through the representation of clearly recognisable people. They were not sentimentalised or comic, as in British posters, or heroic, like the Germans. Ordinary French soldiers were drawn from life, from the men passing through the stations of Paris on the way back to the front. Women became Marianne, the traditional emblem of Republican France. Both lived in a landscape that supported and nurtured them. It was a clear national aesthetic, serious and austere that reflected the gravitas of the threat to France levelled by the war.

The United States too was a republic. But it was brash and energetic, and, once part of the war, saw the struggle as a crusade for democracy itself. America's powerful self-confidence jumped out of the images it used both to raise funds and enlist volunteers. The commercial pressures seen at the height of the PRC's campaign in Britain in 1915 reasserted themselves in America in 1917–1918. Loud colours and words, feisty men and women, promises of salvation, all tumbled out of over 700 poster designs produced in the United States. Moving the agenda back to where it had started almost three years earlier, the advertising men once again made the war a national cause.

The posters of the First World War provide a sharp and vibrant reflection of the underlying beliefs and values of this devastating global event. The balance of the design changes from country to country. The message they carry shifts from year to year. But, despite this, they remain arresting and appealing to this day. The artists and printers who created them established enduring works of popular art that still convey the strength and determination of every country to prevail. These posters remind us then of the real tragedy of the First World War – that the people of so many nations across both Europe and the world each believed their own cause to be right, and the war to be just.

Nigel Steel, Principal Historian
First World War Centenary Programme

UNKNOWN, ENGLAND EXPECTS EVERY MAN TO DO HIS DUTY, 1914, GREAT BRITAIN

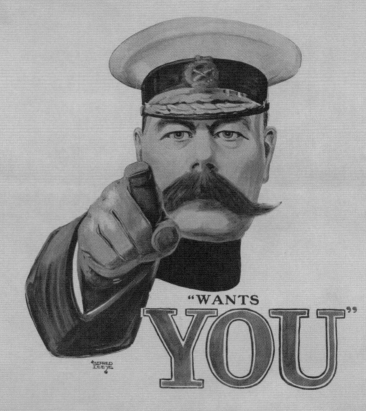

ALFRED LEETE, BRITONS. JOIN YOUR COUNTRY'S ARMY!, 1914, GREAT BRITAIN

TO THE
YOUNG WOMEN
OF LONDON

Is your "Best Boy" wearing Khaki? If not don't **YOU THINK** he should be?

If he does not think that you and your country are worth fighting for—do you think he is **WORTHY** of you?

Don't pity the girl who is alone—her young man is probably a soldier—fighting for her and her country—and for **YOU.**

If your young man neglects his duty to his King and Country, the time may come when he will **NEGLECT YOU.**

Think it over—then ask him to

JOIN THE ARMY TO-DAY

Printed by David Allen & Sons Ltd., Harrow, London, etc.

UNKNOWN, TO THE YOUNG WOMEN OF LONDON, 1915, GREAT BRITAIN

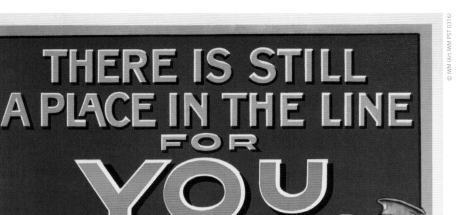

THERE IS STILL
A PLACE IN THE LINE
FOR
YOU

THIS SPACE IS RESERVED FOR A FIT MAN

Will you fill it?

PUBLISHED BY THE PARLIAMENTARY RECRUITING COMMITTEE, LONDON. POSTER No 35 THE HAYCOCK-CADLE Co LONDON. S.E.
(W. 11688/291. 10 M. 2/15) H C Co

UNKNOWN, THERE IS STILL A PLACE IN THE LINE FOR YOU, 1915, GREAT BRITAIN

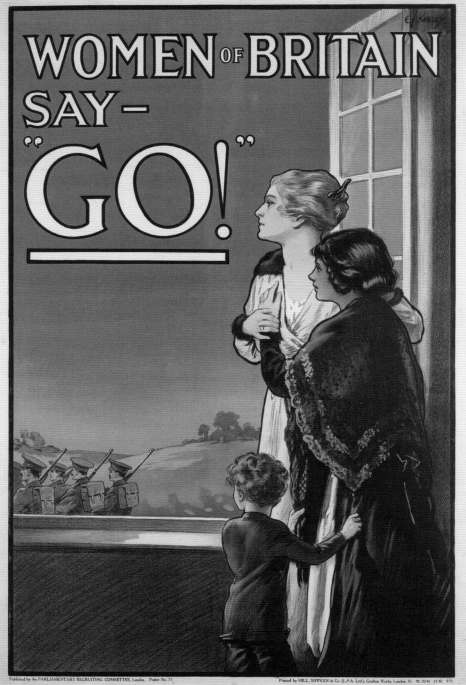

E J KEALEY, WOMEN OF BRITAIN SAY 'GO!', 1915, GREAT BRITAIN

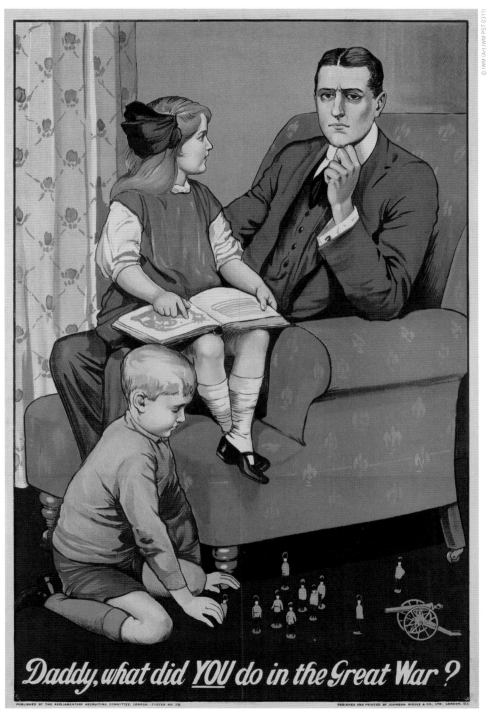

SAVILE LUMLEY, DADDY, WHAT DID YOU DO IN THE GREAT WAR?, 1915, GREAT BRITAIN

IF THE CAP FITS YOU

JOIN THE ARMY TO-DAY.

UNKNOWN, IF THE CAP FITS YOU JOIN THE ARMY TODAY, DATE UNKNOWN, GREAT BRITAIN

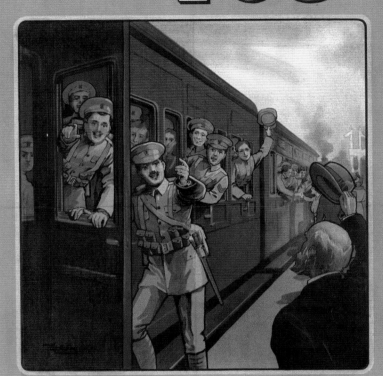

W A FRY, THERE'S ROOM FOR YOU, 1915, GREAT BRITAIN

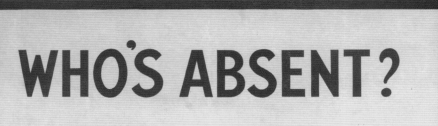

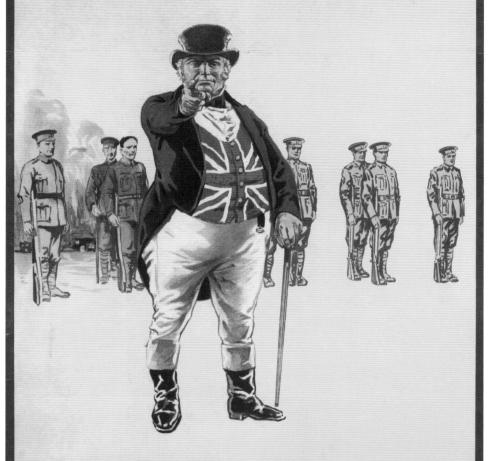

UNKOWN, WHO'S ABSENT?, 1915, GREAT BRITAIN

FORWARD!

Forward to Victory
ENLIST NOW

LUCY KEMP-WELCH, FORWARD!, 1915, GREAT BRITAIN

TO ARMS!

Samples of

PURE GRIT

Are to be met in abundance in all Training Camps.

GAME COCKS

Cleaning their Spurs.

BIRDS OF THE FEATHER

Welcomed by Fellow-Sports.

NIP INTO THE RING, COBBER,

.. and ..

WIN FAME!

"STIFFEN THE SINEWS, SUMMON UP THE BLOOD!"

ADVERTISER PRINT, ADELAIDE. (Sgd.) J. NEWLAND, Chairman State Recruiting Committee, 4th Military District.

UNKNOWN, TO ARMS!, 1914, AUSTRALIA

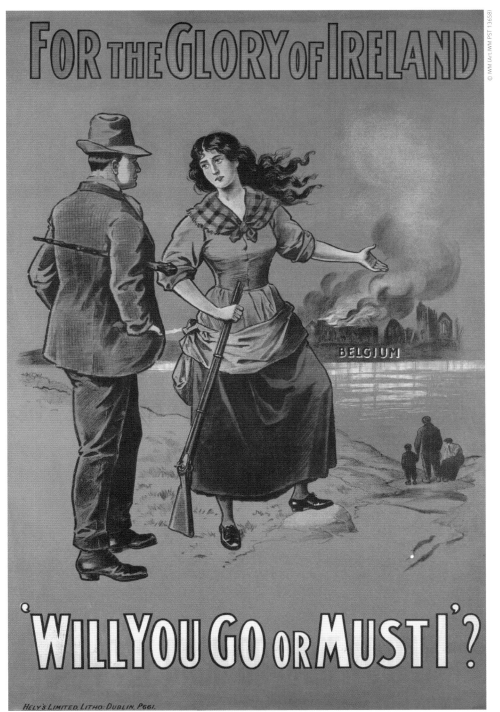

UNKNOWN, FOR THE GLORY OF IRELAND, 1915, IRELAND

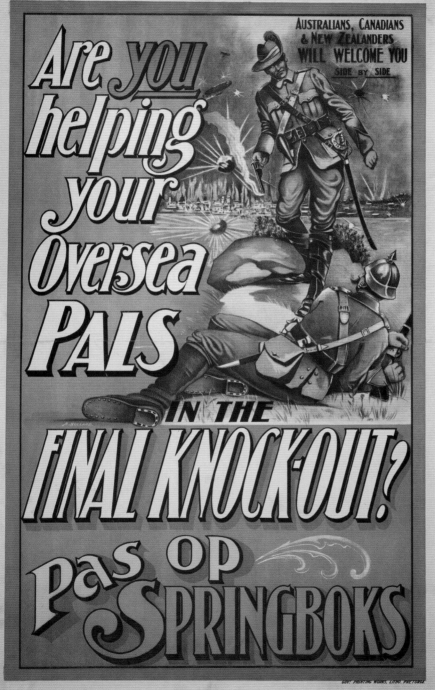

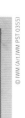

A HOLLAND, ARE YOU HELPING YOUR OVERSEAS PALS IN THE FINAL KNOCKOUT?, C.1916, SOUTH AFRICA

DAVID HENRY SOUTER, IT IS NICE IN THE SURF BUT WHAT ABOUT THE MEN IN THE TRENCHES, 1917, AUSTRALIA

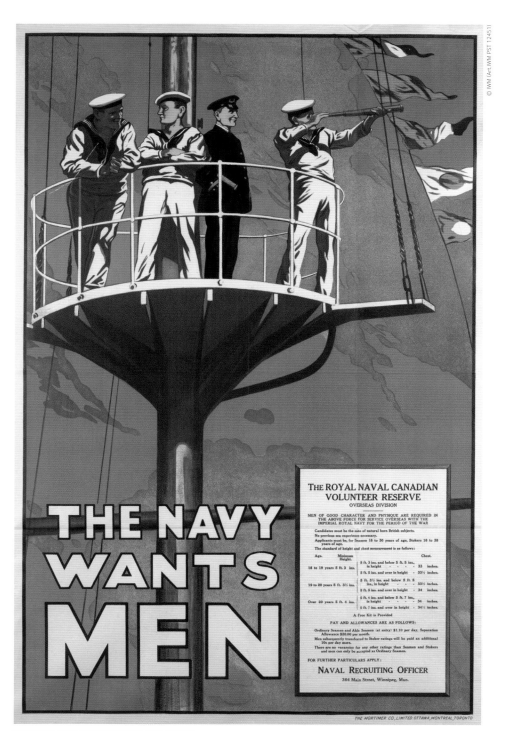

UNKNOWN, THE NAVY WANTS MEN, 1917, CANADA

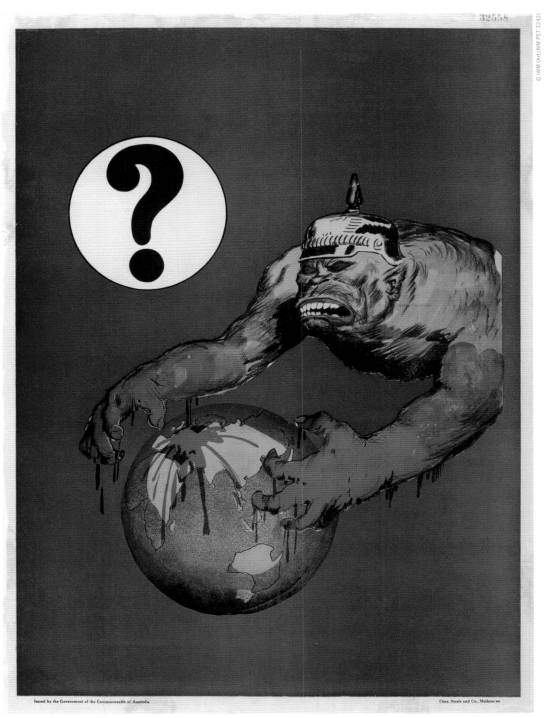

Issued by the Government of the Commonwealth of Australia. Chas. Steele and Co., Melbourne

NORMAN ALFRED WILLIAM LINDSAY, ? (THE QUESTION MARK), 1918, AUSTRALIA

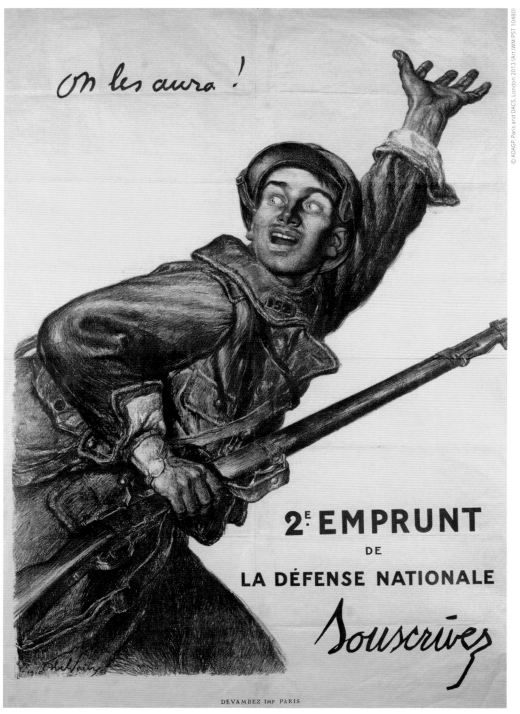

JULES ABEL FAIVRE, WE'LL GET THEM!, 1916, FRANCE

LEND YOUR FIVE SHILLINGS TO YOUR COUNTRY AND

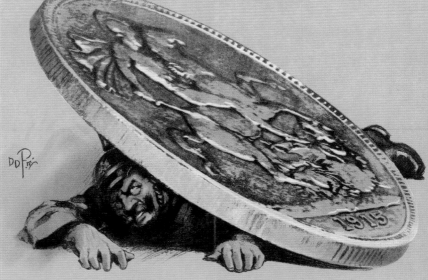

CRUSH THE GERMANS

PUBLISHED BY THE PARLIAMENTARY WAR SAVINGS COMMITTEE, LONDON POSTER Nº23 PRINTED BY DAVID ALLEN & SONS Lº. HARROW, MIDDLESEX, W.6112 40M 3/15.

D D P, LEND YOUR FIVE SHILLINGS, 1915, GREAT BRITAIN

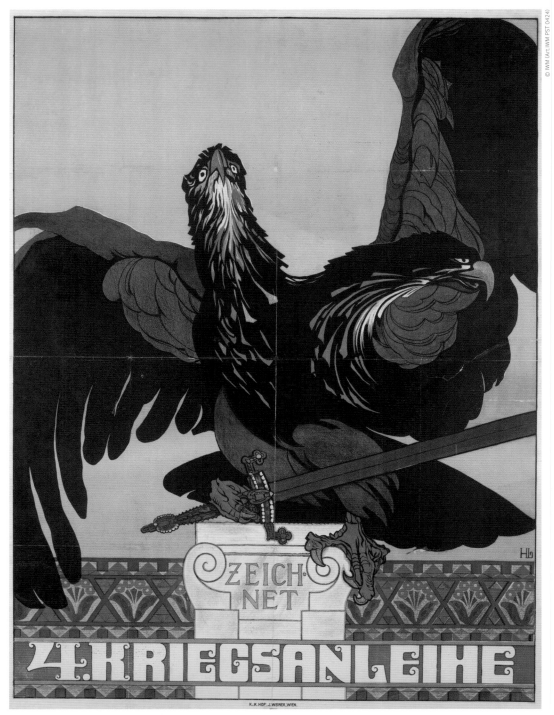

HEINRICH LEFLER, SUBSCRIBE TO THE FOURTH WAR LOAN, 1916, AUSTRIA-HUNGARY

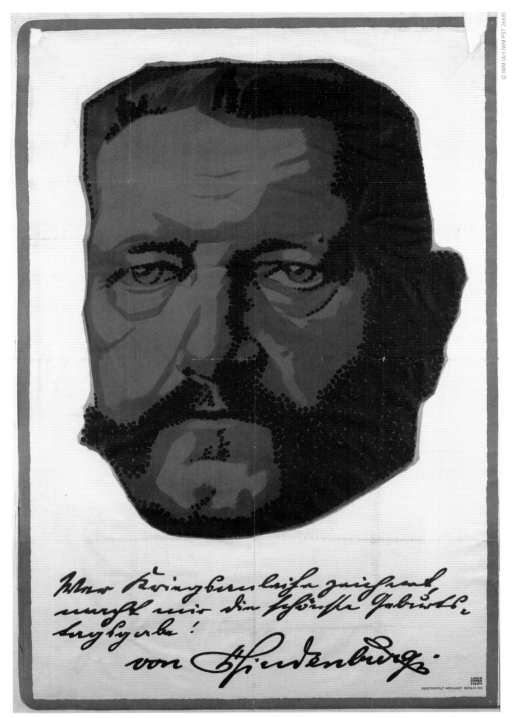

LOUIS OPPENHEIM, ANYONE WHO SUBSCRIBES TO THE WAR LOAN IS GIVING ME
THE SUPREME BIRTHDAY PRESENT – VON HINDENBURG, 1917, GERMANY

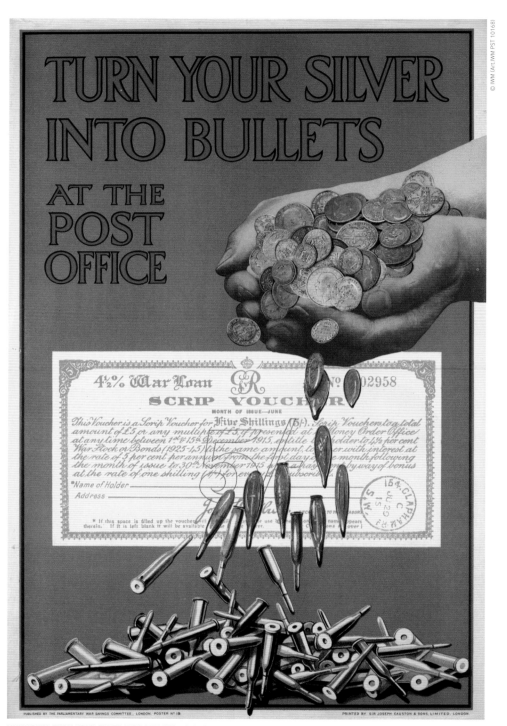

UNKNOWN, TURN YOUR SILVER INTO BULLETS, 1915, GREAT BRITAIN

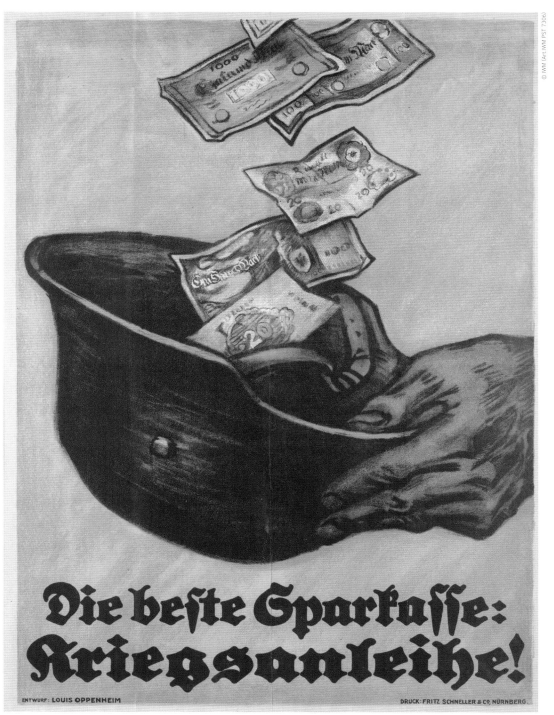

LOUIS OPPENHEIM, THE BEST SAVINGS BANK – THE WAR LOAN!, 1918, GERMANY

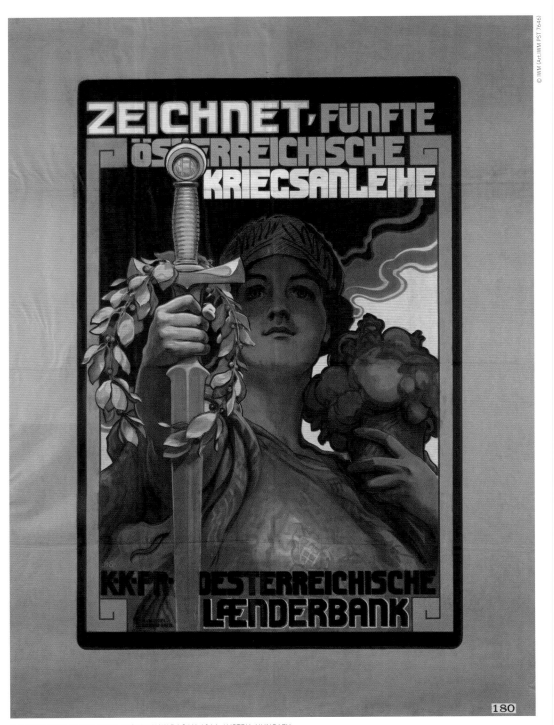

180

A S, SUBSCRIBE TO THE FIFTH AUSTRIAN WAR LOAN, 1916, AUSTRIA-HUNGARY

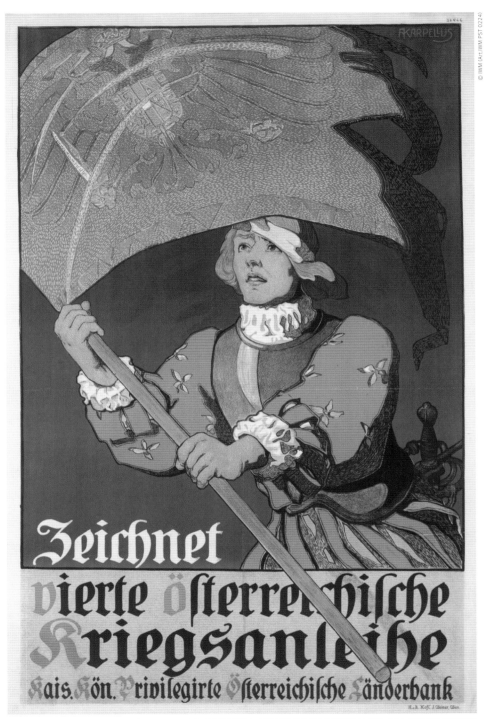

Zeichnet
vierte österreichische
Kriegsanleihe
Kais. Kön. Privilegirte Österreichische Länderbank

ADOLF KARPELLUS, SUBSCRIBE TO THE FOURTH AUSTRIAN WAR LOAN, 1916, AUSTRIA-HUNGARY

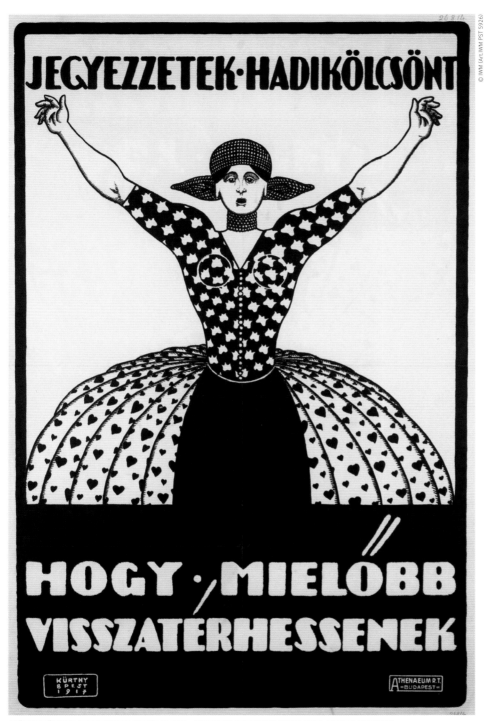

GYÖRGY KÜRTHY, SUBSCRIBE TO THE WAR LOAN – FOR THEM TO RETURN SOON, 1917, AUSTRIA-HUNGARY

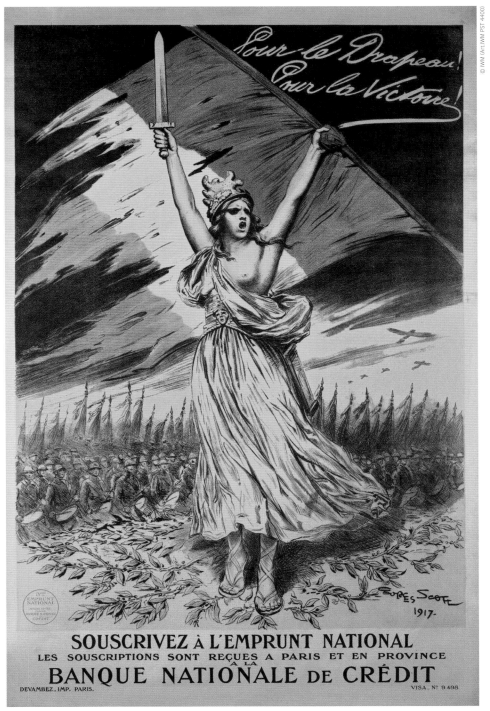

GEORGES SCOTT, FOR THE FLAG! FOR VICTORY!, 1917, FRANCE

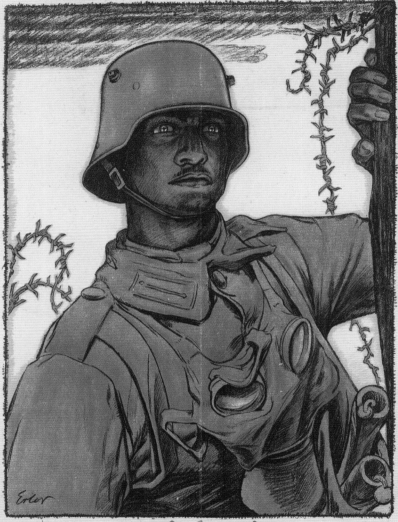

FRITZ ERLER, HELP US WIN!, 1917, GERMANY

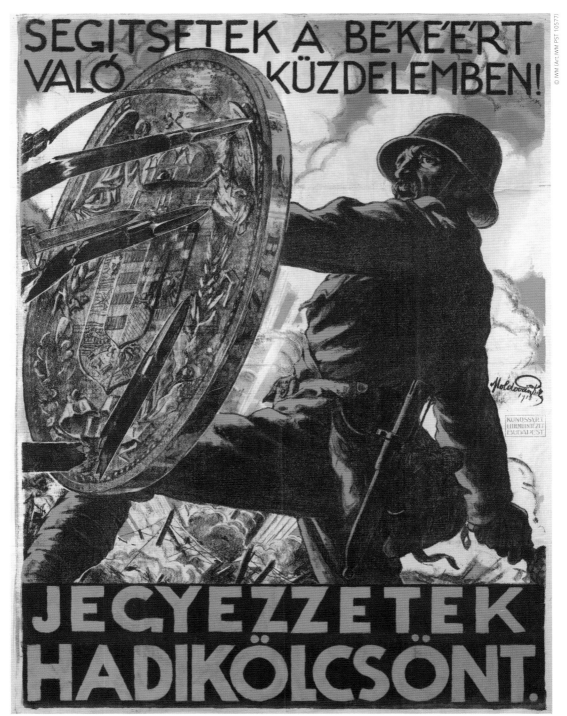

BÉLA MOLDOVÁN, SUBSCRIBE TO THE WAR LOAN, 1918, AUSTRIA-HUNGARY

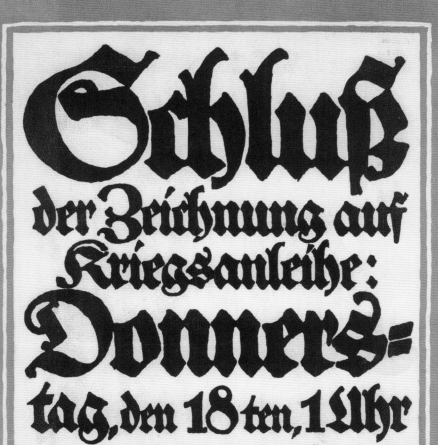

LUCIAN BERNHARD, CLOSURE OF WAR LOAN SUBSCRIPTIONS, 1918, GERMANY

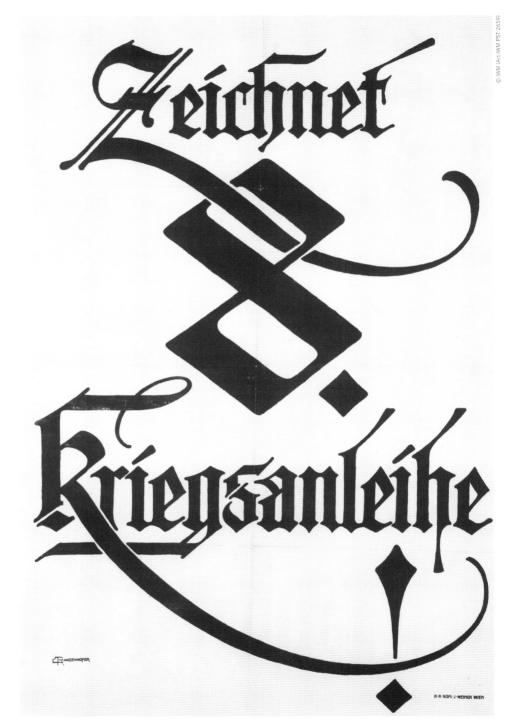

EMIL RANZENHOFER, SUBSCRIBE TO THE EIGHTH WAR LOAN!, 1918, AUSTRIA-HUNGARY

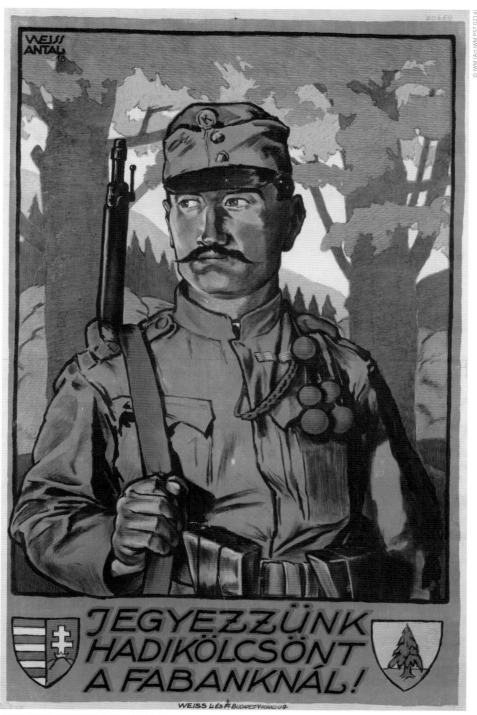

ANTAL WEISS, SUBSCRIBE TO THE WAR LOAN AT FABANK!, 1918, AUSTRIA-HUNGARY

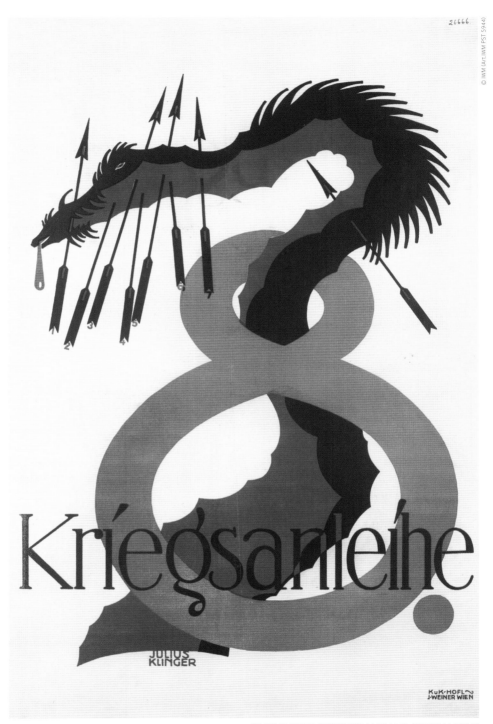

JULIUS KLINGER, EIGHTH WAR LOAN, 1918, AUSTRIA-HUNGARY

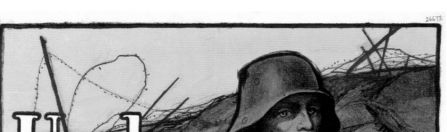

ALFRED ROLLER, WHAT ABOUT YOU? SUBSCRIBE TO THE SEVENTH WAR LOAN, 1917, AUSTRIA-HUNGARY

UNKNOWN, WAR WEAPONS WEEK, 1918, GREAT BRITAIN

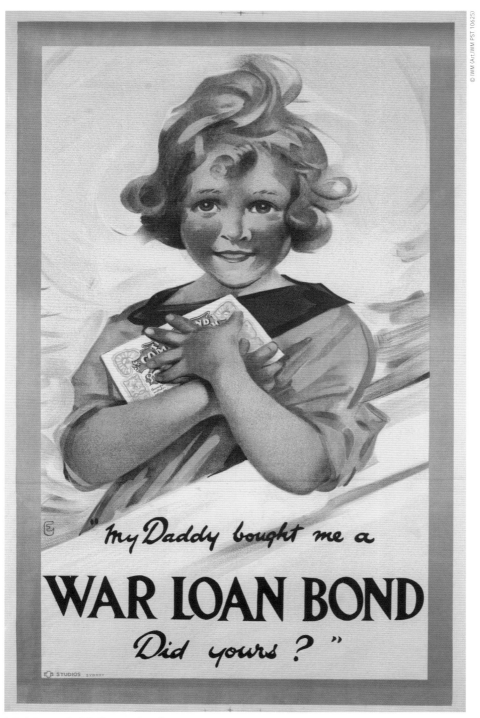

A E, MY DADDY BOUGHT ME A WAR LOAN BOND, DATE UNKNOWN, AUSTRALIA

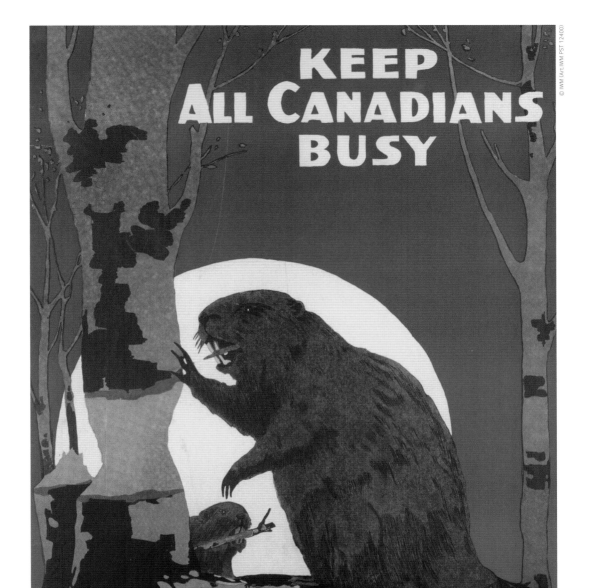

UNKNOWN, KEEP ALL CANADIANS BUSY, 1918, CANADA

രണ്ടാമത്തെ ഇന്ത്യ യുദ്ധാവായ്പ

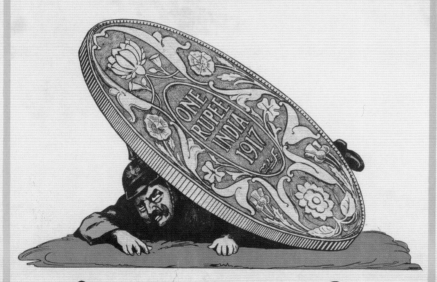

നിങ്ങളുടെ ഉറുപ്പിക സ്വരാജ്യസംരക്ഷണക്കായി വായ്പ കൊടുത്ത് ജന്മൻകാരെ നശിപ്പിക്കുവാൻ സഹായിക്കുക

Litho Addison Press Madras

UNKNOWN, LEND YOUR FIVE SHILLINGS, DATE UNKNOWN, INDIA

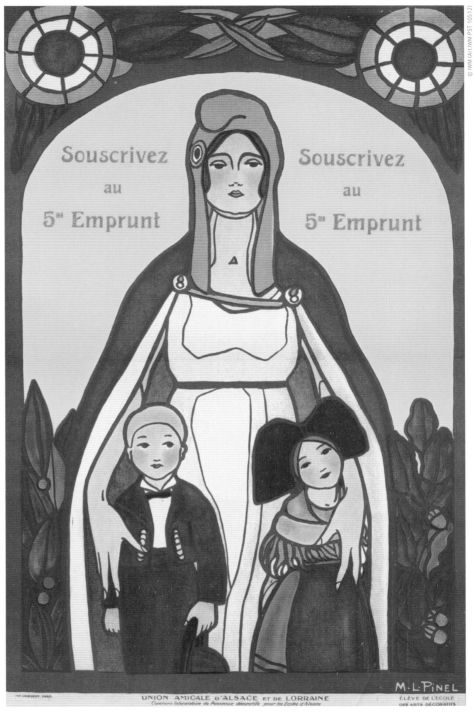

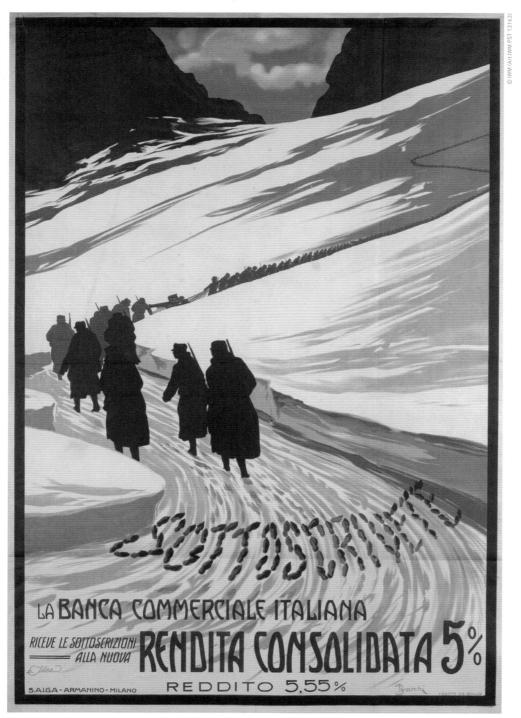

BARCHI, SUBSCRIBE, C.1917, ITALY

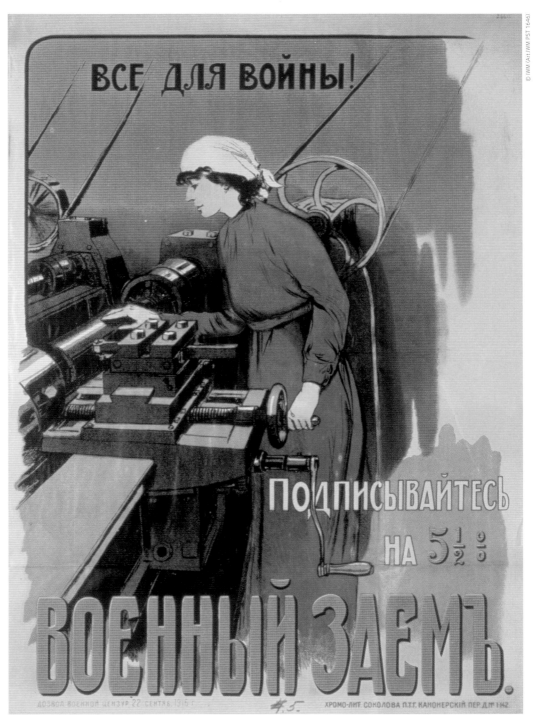

UNKNOWN, ALL FOR WAR! – SUBSCRIBE TO THE FIVE AND A HALF PER CENT WAR LOAN, 1916, RUSSIA

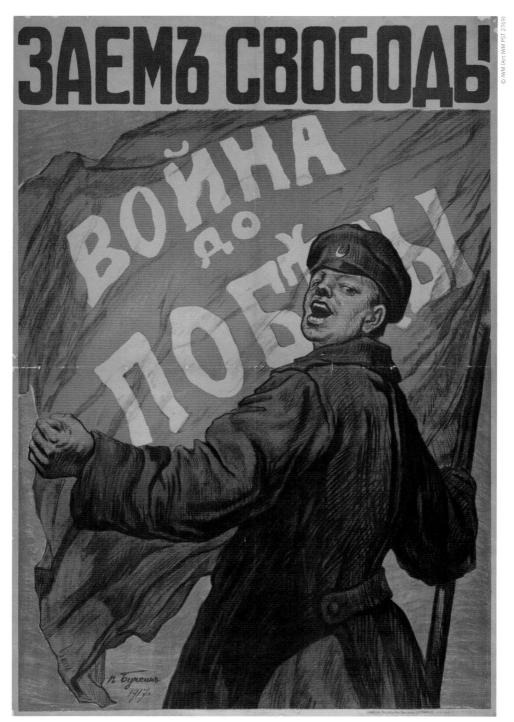

PETER BUTCHKIN, FREEDOM LOAN — WAR UNTIL VICTORY, 1917, RUSSIA

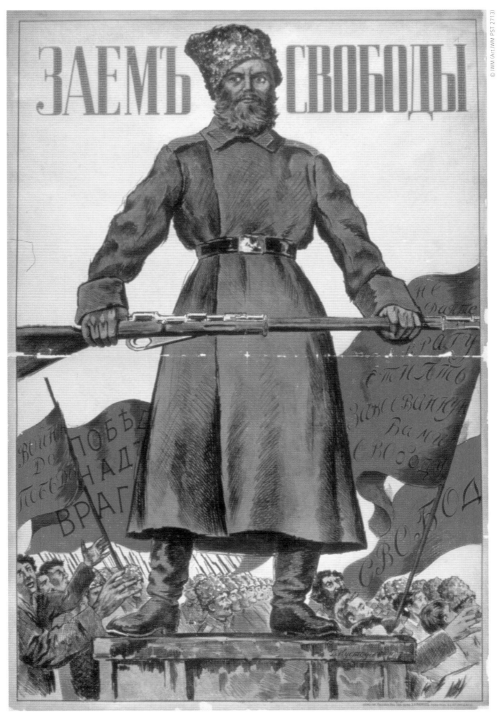

BORIS MIKAJLOVICH KUSTODIEV, FREEDOM LOAN, 1917, RUSSIA

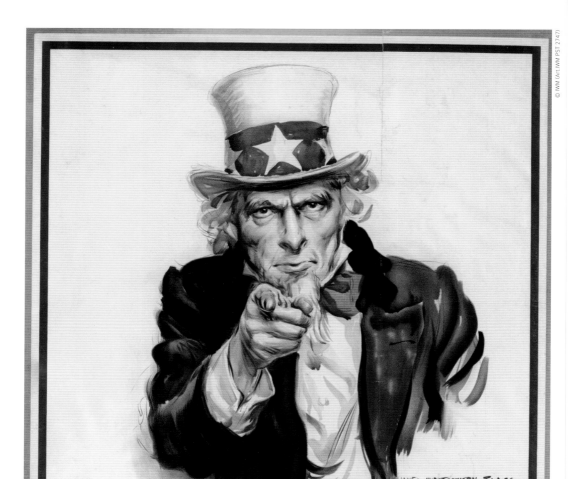

JAMES MONTGOMERY FLAGG, I WANT YOU FOR US ARMY, 1917, USA

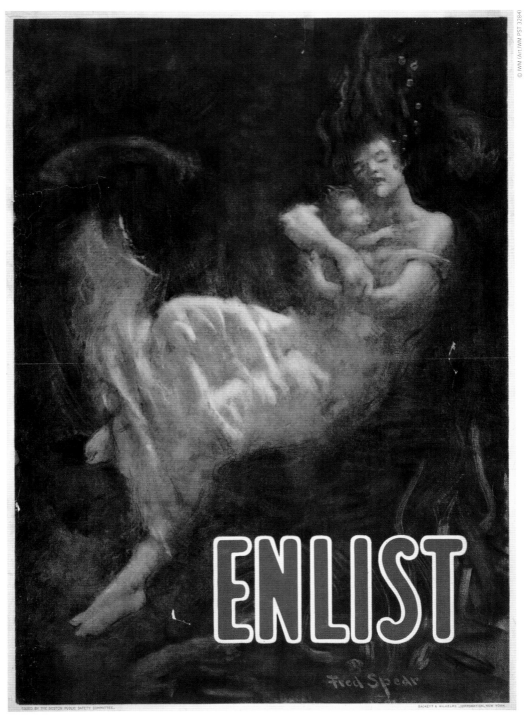

FRED SPEAR, ENLIST, DATE UNKNOWN, USA

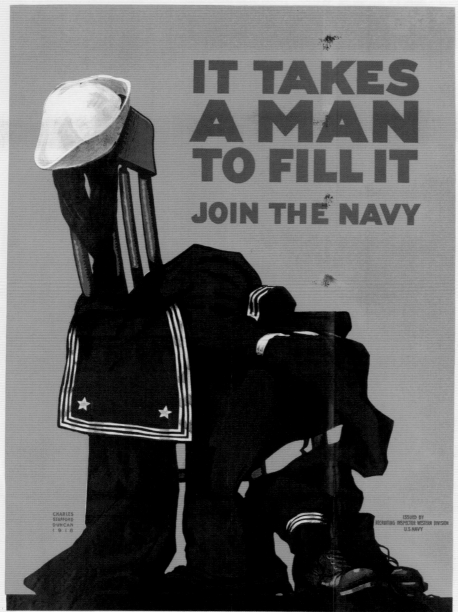

CHARLES STAFFORD DUNCAN, IT TAKES A MAN TO FILL IT – JOIN THE NAVY, 1917, USA

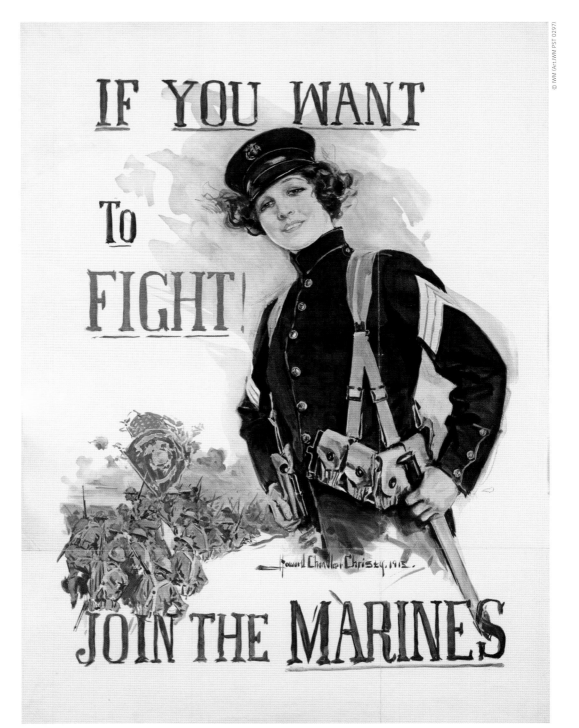

HOWARD CHANDLER CHRISTY, IF YOU WANT TO FIGHT! JOIN THE MARINES, 1918, USA

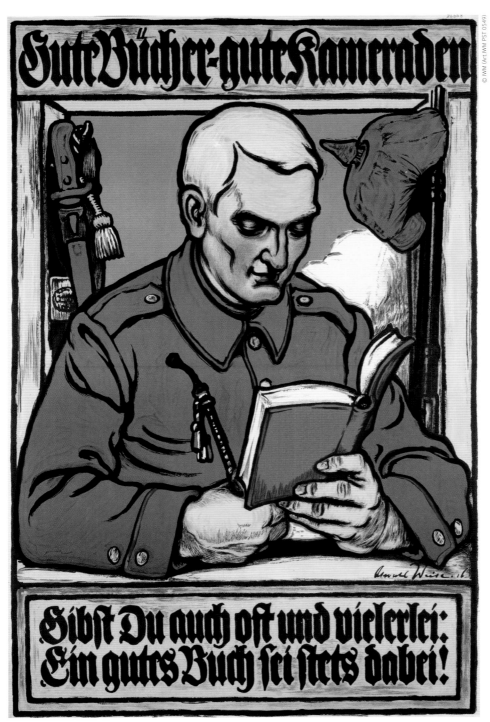

OSWALD WEISE, GOOD BOOKS – GOOD COMRADES, 1916, GERMANY

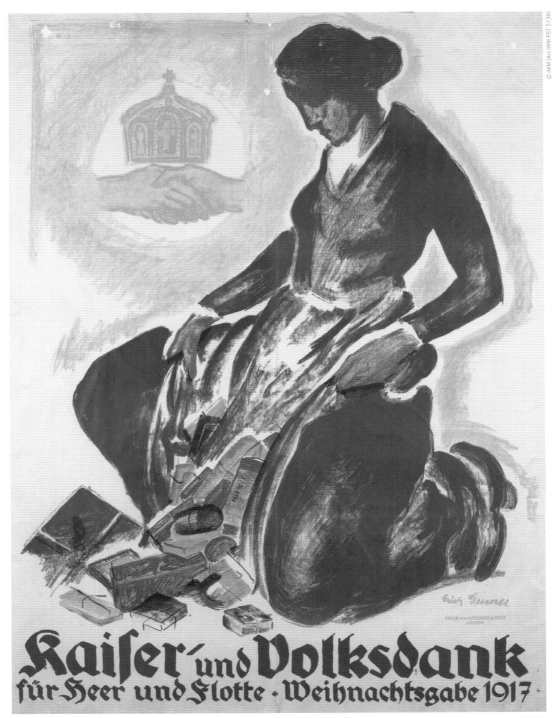

ERICH GRÚNER, KAISER'S AND PEOPLE'S THANKS, 1917, GERMANY

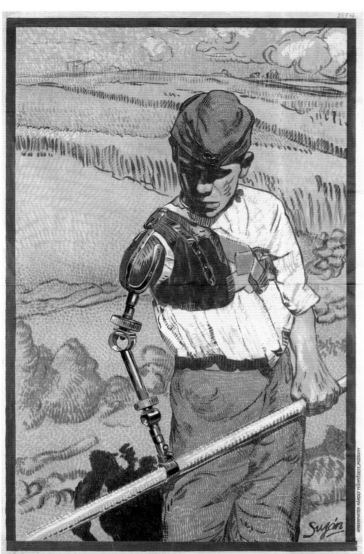

PÁL SUJÁN, NATIONAL EXHIBITION OF WAR-INVALID CARE, 1917, AUSTRIA-HUNGARY

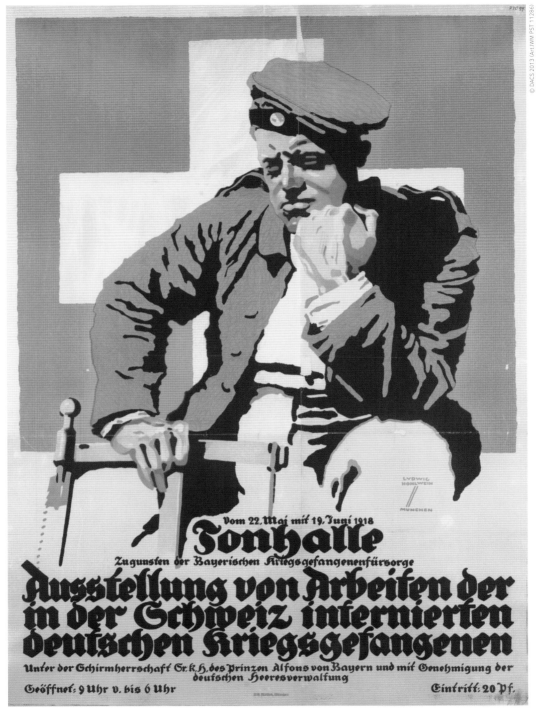

LUDWIG HOHLWEIN, EXHIBITION OF WORK BY GERMAN PRISONERS OF WAR INTERNED IN SWITZERLAND, 1918, GERMANY

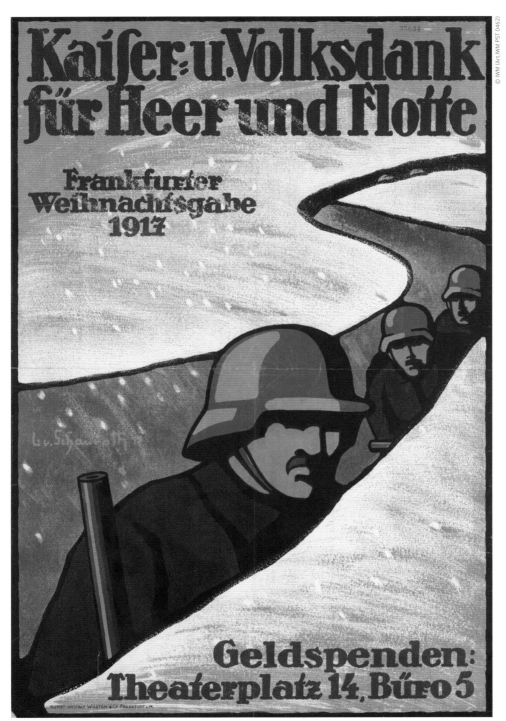

LINA VON SCHAUROTH, IMPERIAL AND POPULAR CHARITY FUND FOR THE ARMY AND NAVY, 1917, GERMANY

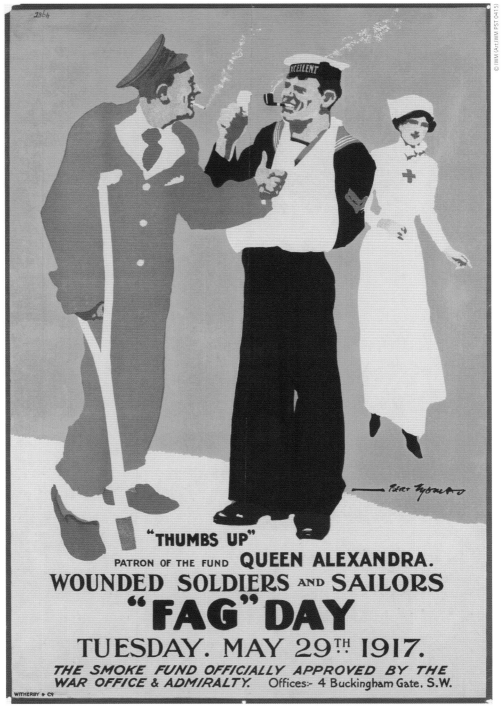

"THUMBS UP"

PATRON OF THE FUND QUEEN ALEXANDRA.

WOUNDED SOLDIERS AND SAILORS

"FAG" DAY

TUESDAY. MAY 29TH 1917.

THE SMOKE FUND OFFICIALLY APPROVED BY THE
WAR OFFICE & ADMIRALTY. Offices:- 4 Buckingham Gate, S.W.

WITHERBY & C9

BERT THOMAS, FAG DAY, 1917, GREAT BRITAIN

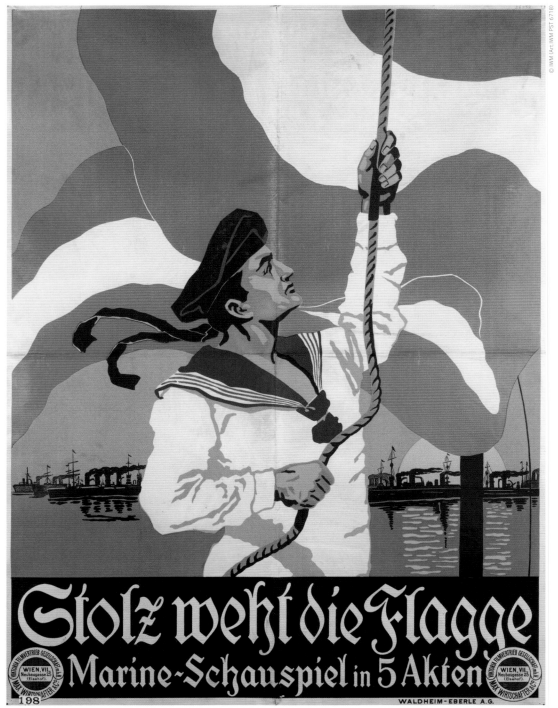

UNKNOWN, PROUDLY WAVES THE FLAG, 1918, AUSTRIA-HUNGARY

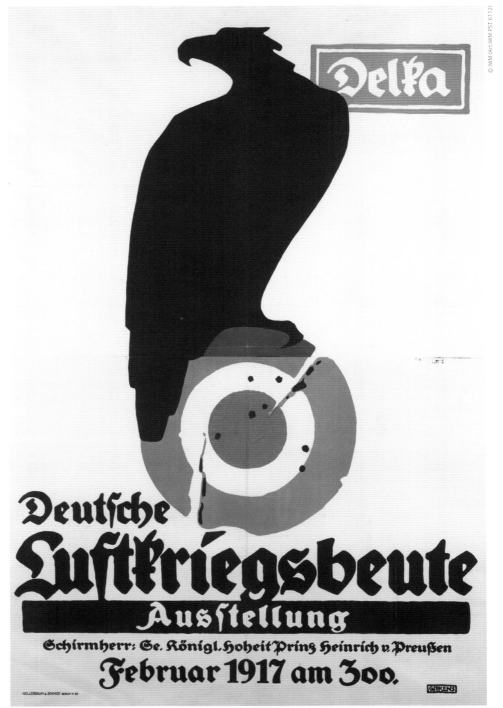

JULIUS GIPKENS, DELKA – GERMAN AIR-WAR TROPHIES EXHIBITION, 1917, GERMANY

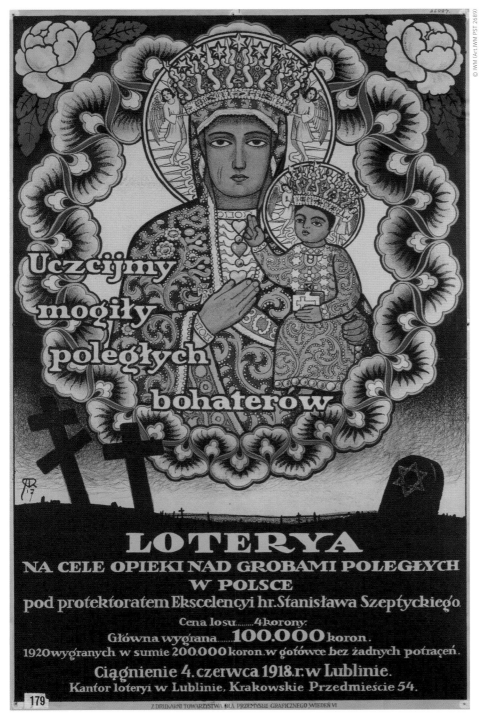

ALFRED ROLLER, LET US HONOUR THE GRAVES OF HEROES, 1918, AUSTRIA-HUNGARY

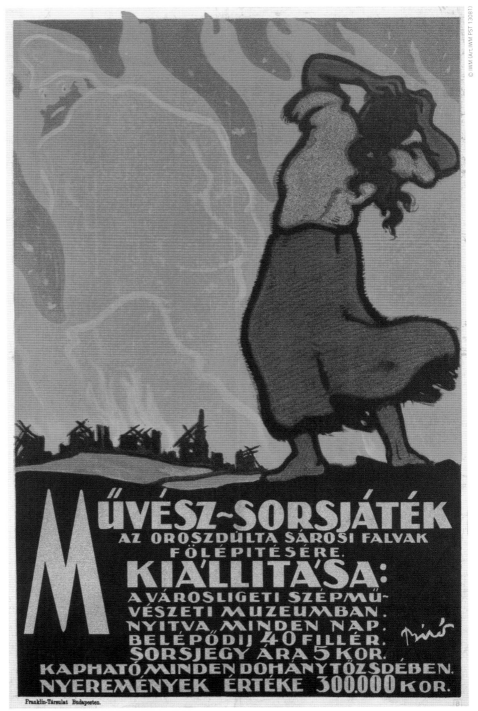

MIHÁLY BIRÓ, ARTISTS' LOTTERY, C.1917, AUSTRIA-HUNGARY

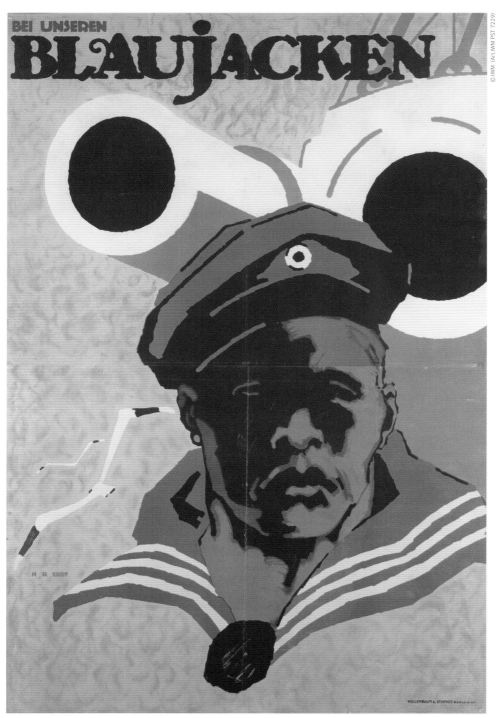

HANS RUDI ERDT, WITH OUR BOYS IN BLUE, 1917, GERMANY

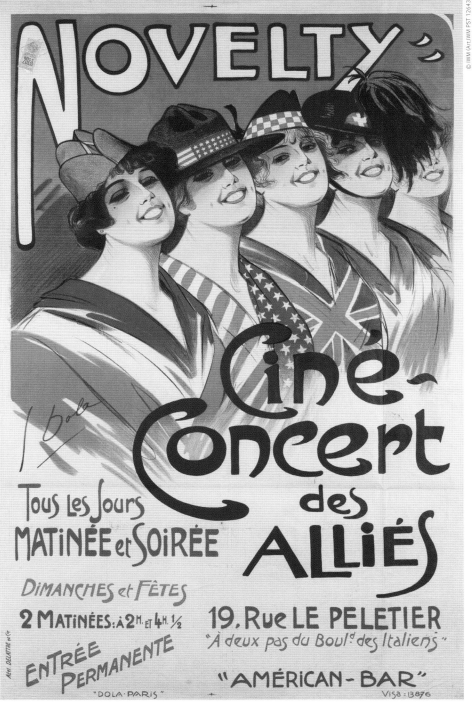

GEORGES DOLA, ALLIES' CINEMA CONCERT, 1918, FRANCE

UNKNOWN, ALCOHOL STIMULATES BUT EXHAUSTS – THOSE WHO USE IT WEAR THEMSELVES OUT, 1915, FRANCE

UNKNOWN, ALCOHOL EXTINGUISHES THE MAN TO AROUSE THE BEAST, 1915, FRANCE

UNKNOWN, ABSINTH SENDS YOU MAD, 1916, FRANCE

UNKNOWN, ALL ALCOHOLS ARE POISONS, 1915, FRANCE

UNKNOWN, A DRINKER'S HOUSE, AN UNHAPPY HOUSE, 1915, FRANCE

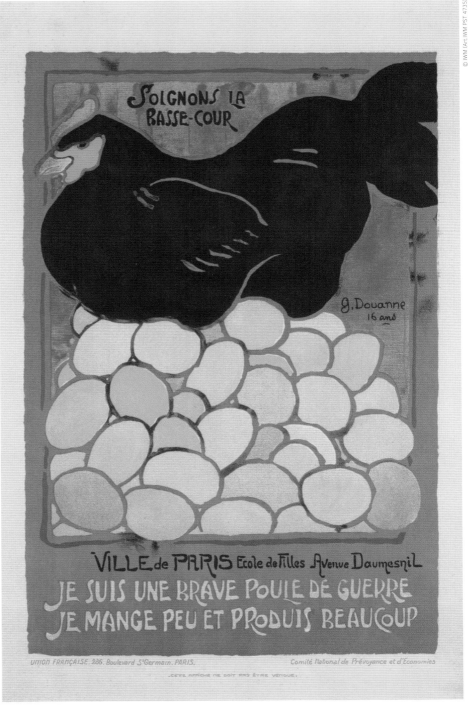

G DOUANNE, LET'S LOOK AFTER THE FARMYARD, 1916, FRANCE

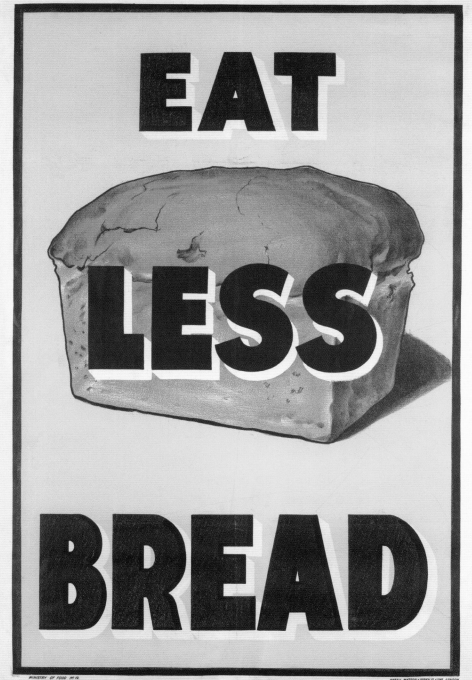

UNKNOWN, EAT LESS BREAD, 1917, GREAT BRITAIN

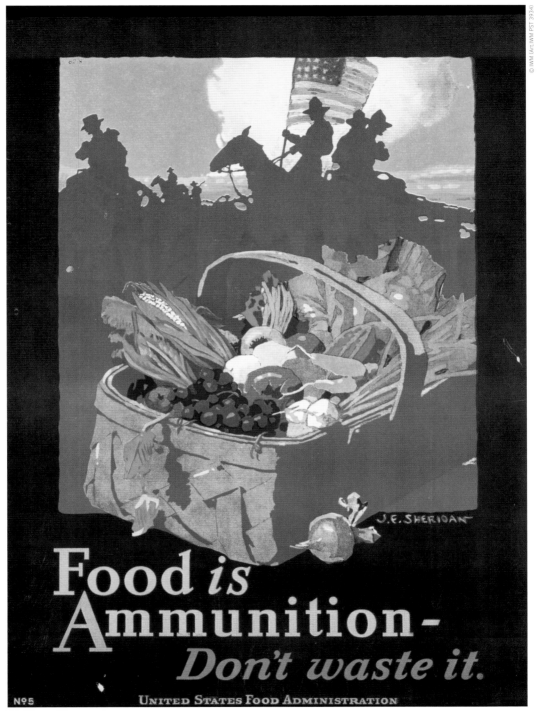

JOHN E SHERIDAN, FOOD IS AMMUNITION – DON'T WASTE IT, 1918, USA

JUPP WIERTZ, COLLECT WOMEN'S HAIR!, 1918, GERMANY

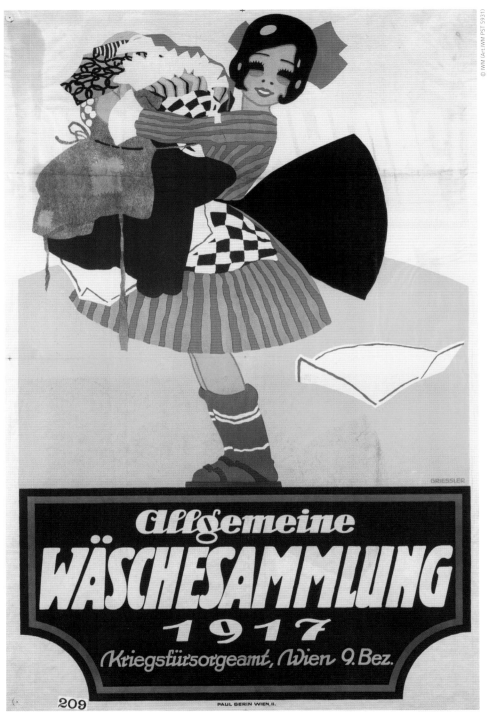

FRANZ GRIESSLER, GENERAL COLLECTION OF LAUNDRY, 1917, AUSTRIA-HUNGARY

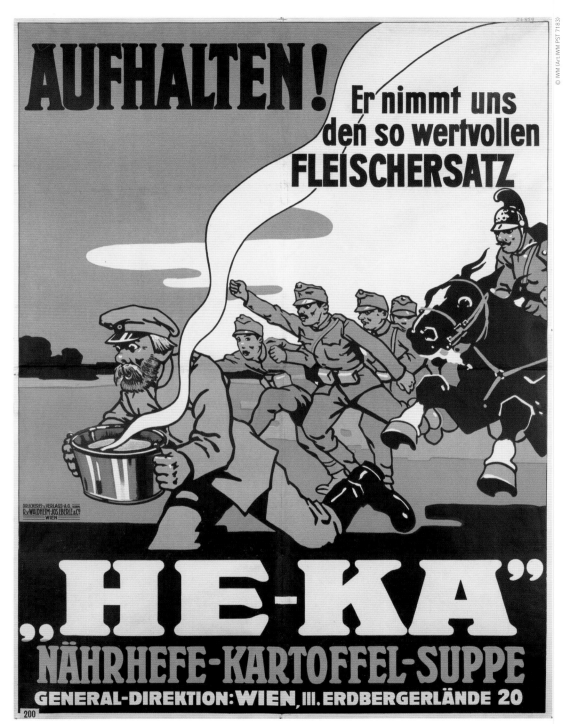

UNKNOWN, STOP HIM!, C.1916, AUSTRIA-HUNGARY

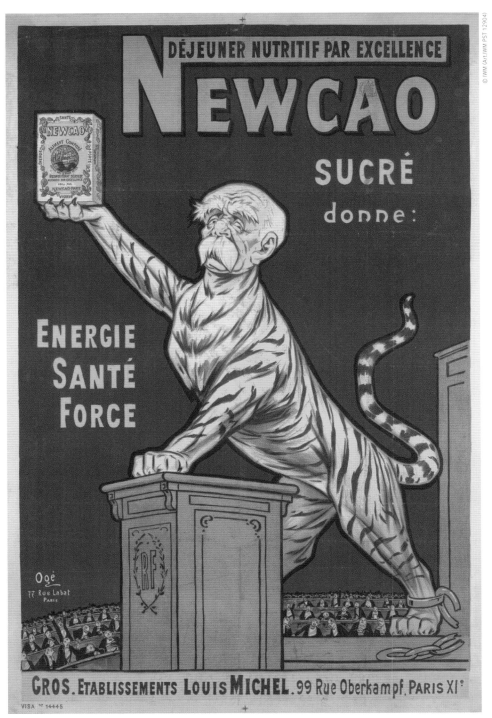

UNKNOWN, NEWCAO – NUTRITIOUS BREAKFAST PAR EXCELLENCE, 1917, FRANCE

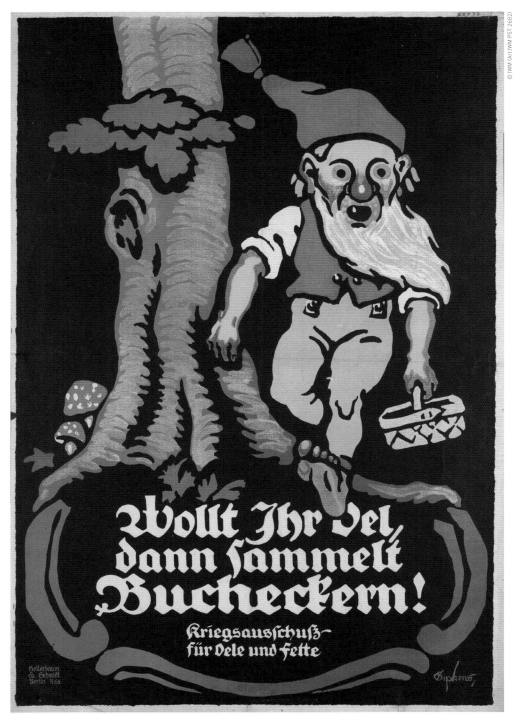

JULIUS GIPKENS, IF YOU WANT OIL, COLLECT BEECHNUTS!, 1918, GERMANY

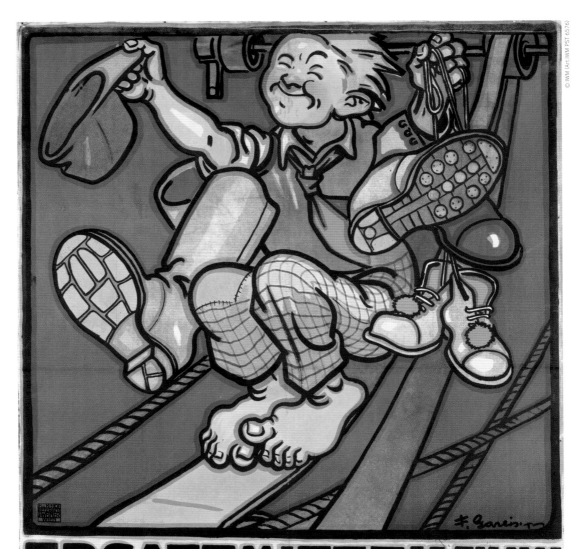

ERSATZMITTEL FMA
AUSSTELLUNG
ABTEILUNG: WIRTSCHAFTSVERBAND
DER LEDERVERARBEITENDEN GEWERBE
MAI-AUGUST 1918 WIEN - KAISERGARTEN

216

FRITZ GAREIS, EXHIBITION OF SUBSTITUTE MATERIALS, 1918, AUSTRIA-HUNGARY

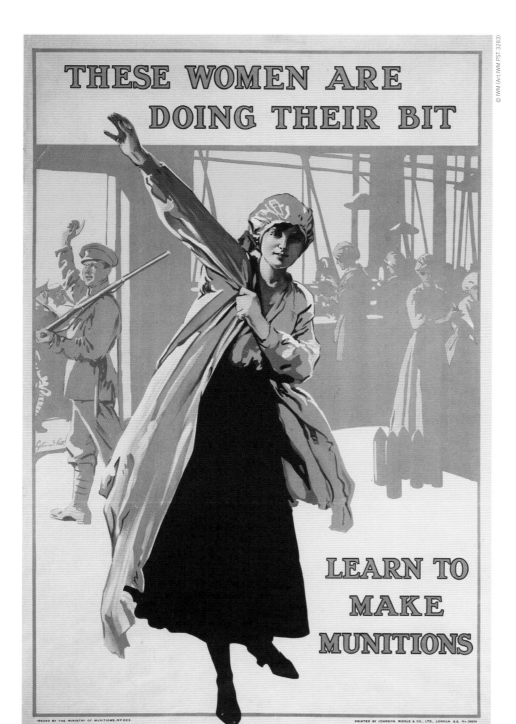

SEPTIMUS SCOTT, THESE WOMEN ARE DOING THEIR BIT, 1916, GREAT BRITAIN

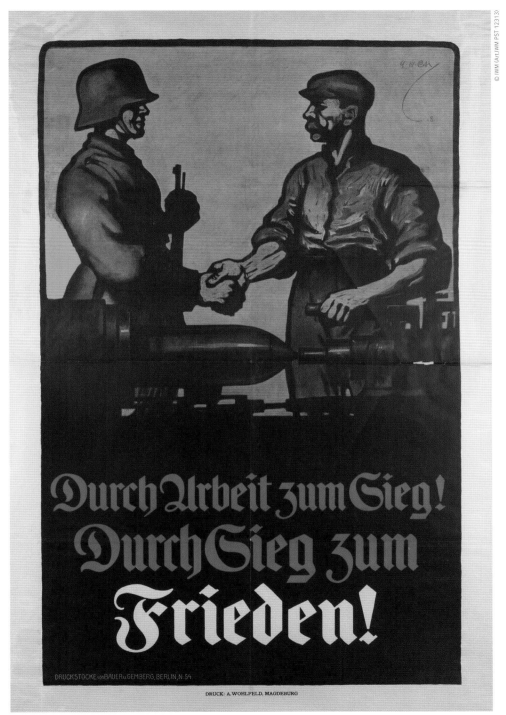

ALEXANDER M CAY, THROUGH WORK TO VICTORY! THROUGH VICTORY TO PEACE!, 1918, GERMANY

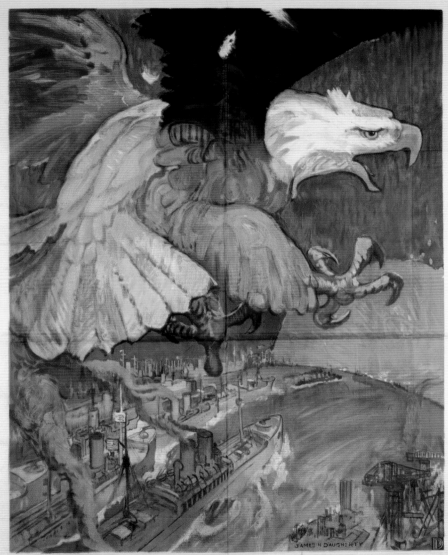

J H DAUGHERTY, SEND THE EAGLE'S ANSWER – MORE SHIPS, 1918, USA

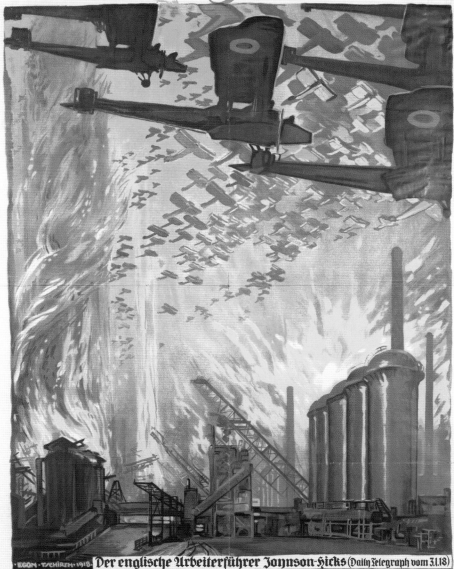

Was England will!

Der englische Arbeiterführer Jonnson-Hicks (Daily Telegraph vom 3.1.18)

„Man muss die rheinischen Industriegebiete mit hundert Flugzeugen Tag für Tag bombardieren, bis die Kur angeschlagen hat!"

DRUCK: SELMAR BAYER, BERLIN SO. 36.

EGON TSCHIRCH, WHAT ENGLAND WANTS!, 1918, GERMANY

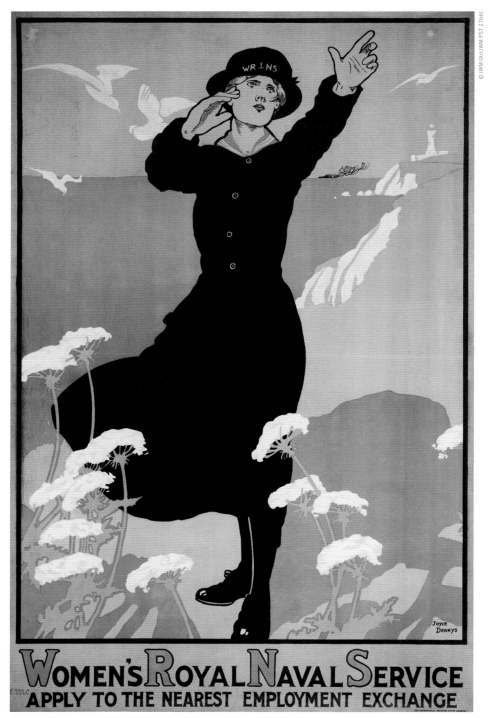

JOYCE DENNYS, WOMEN'S ROYAL NAVAL SERVICE, DATE UNKNOWN, GREAT BRITAIN

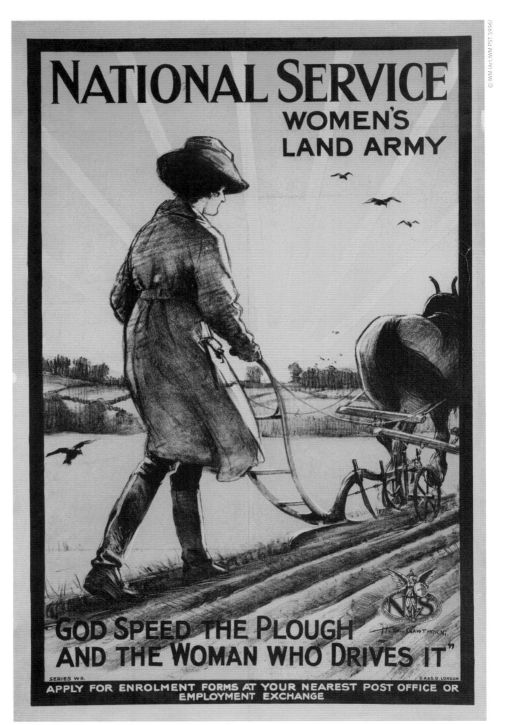

HENRY GEORGE GAWTHORN, NATIONAL SERVICE – WOMEN'S LAND ARMY – GOD
SPEED THE PLOUGH AND THE WOMAN WHO DRIVES IT, 1917, GREAT BRITAIN

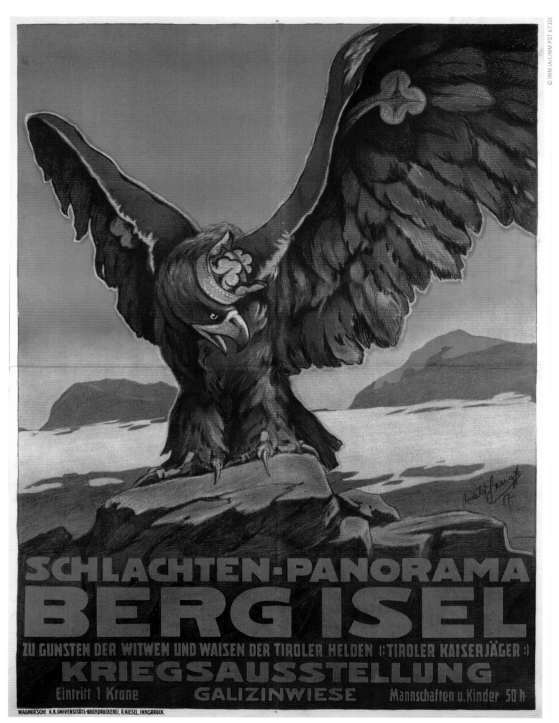

OSWALD HENGST, BATTLE PANORAMA – ISEL MOUNTAIN, 1917, AUSTRIA-HUNGARY

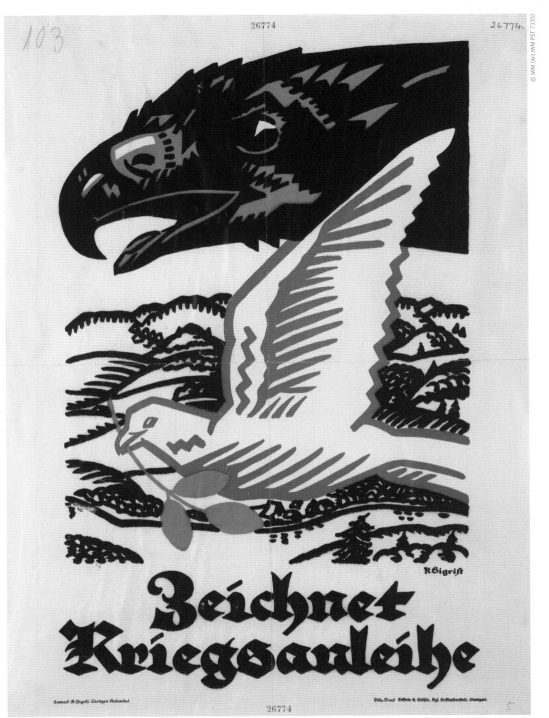

KARL SIGRIST, SUBSCRIBE TO THE WAR LOAN, 1918, GERMANY

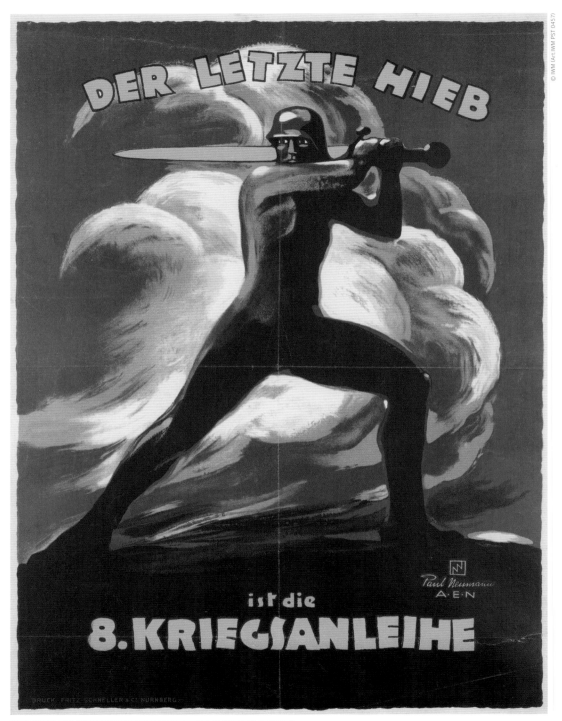

PAUL NEUMANN, THE EIGHTH WAR LOAN IS THE FINAL BLOW, 1918, GERMANY

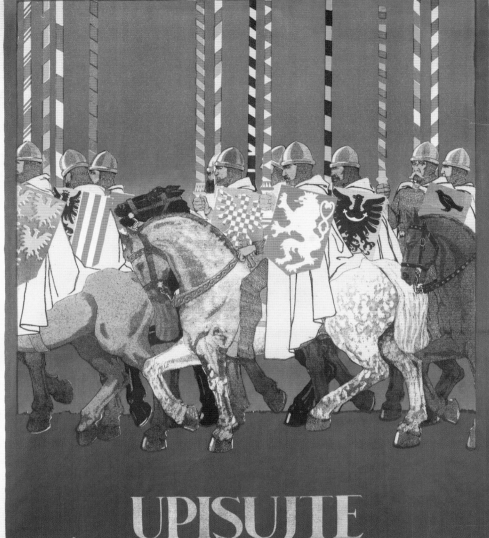

UPISUJTE
PÁTOU VÁLEČNOU
PŮJČKU

"MELANTRICH" PRAHA.

HANU SVOBODA, SUBSCRIBE TO THE FIFTH WAR LOAN, 1916, AUSTRIA-HUNGARY

FRANK BRANGWYN, PUT STRENGTH IN THE FINAL BLOW – BUY WAR BONDS, 1918, GREAT BRITAIN

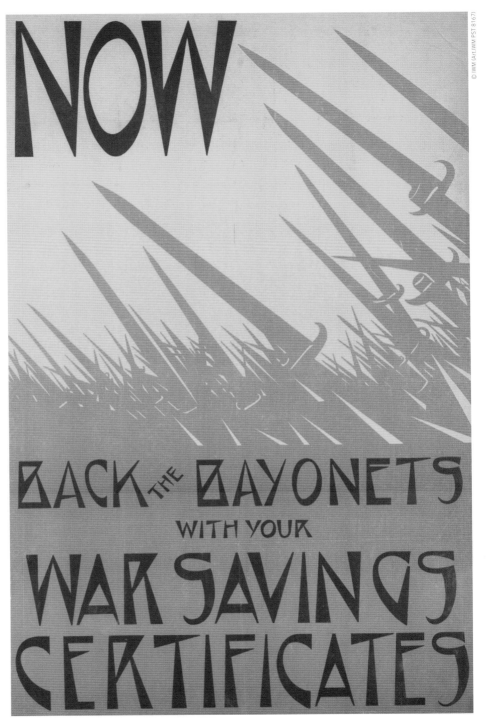

C R W NEVINSON, NOW – BACK THE BAYONETS, 1918, GREAT BRITAIN

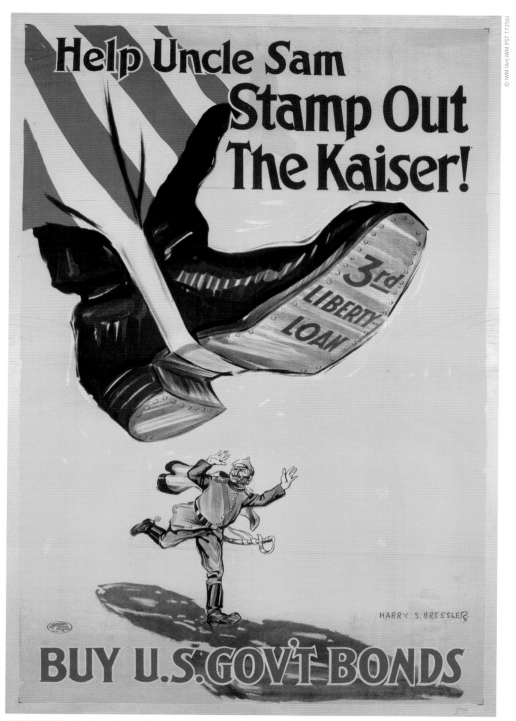

HARRY S BRESSLER, HELP UNCLE SAM STAMP OUT THE KAISER – BUY US GOV'T BONDS, 1918, USA

The Hun –his Mark

Blot it Out

with

LIBERTY BONDS

J ALLEN ST JOHN, THE HUN HIS MARK – BLOT IT OUT WITH LIBERTY BONDS, 1917, USA

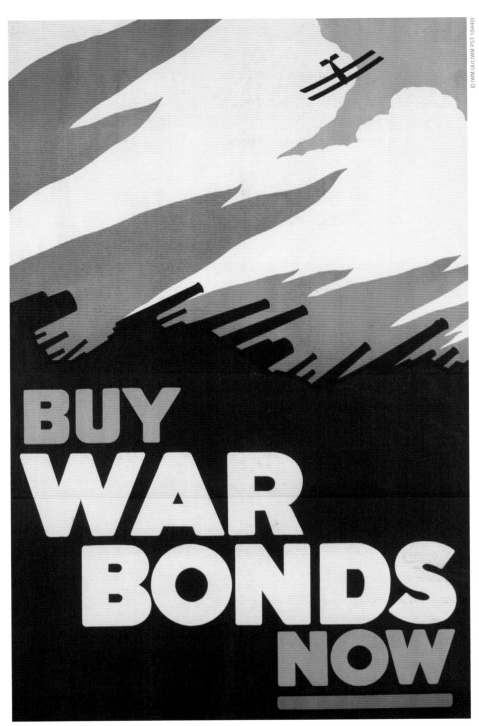

UNKNOWN, BUY WAR BONDS NOW, 1918, GREAT BRITAIN

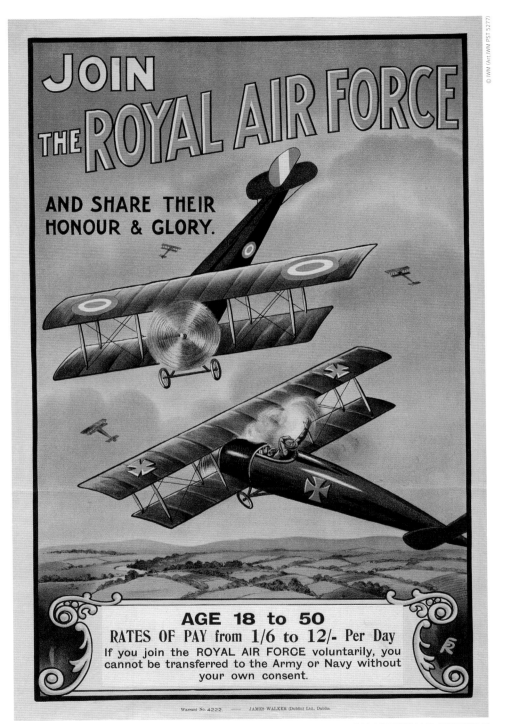

F R, JOIN THE ROYAL AIR FORCE, 1918, GREAT BRITAIN

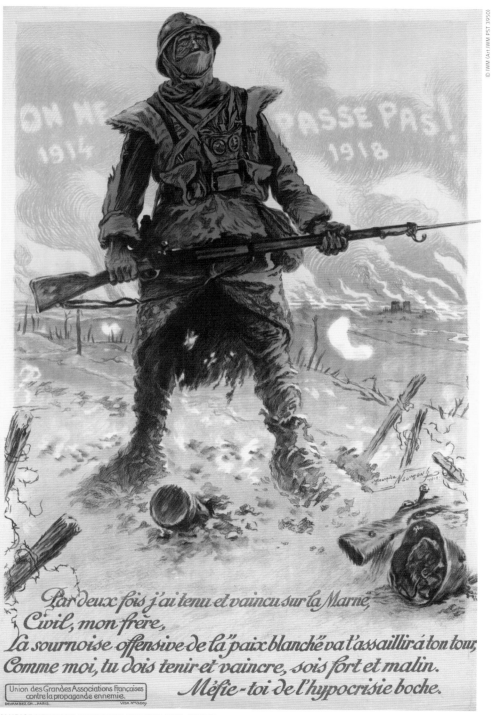

MAURICE NEUMONT, THEY SHALL NOT PASS, 1918, FRANCE

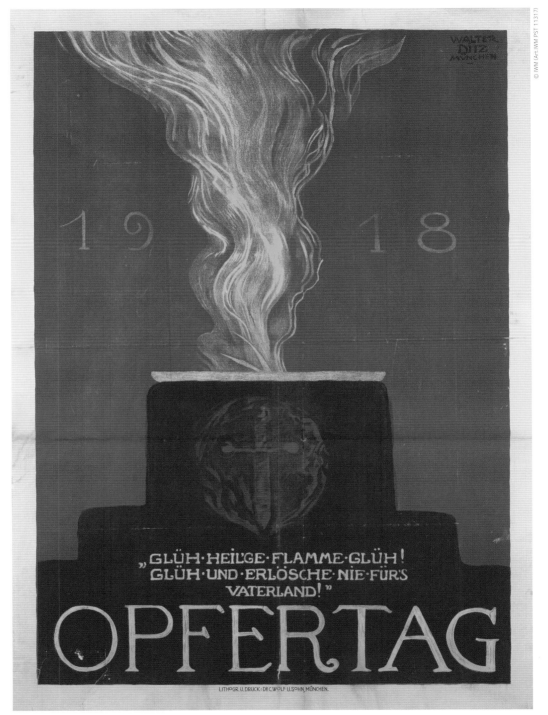

WALTER DITZ, FLAG DAY – BURN SACRED FLAME BURN, BURN AND NEVER CEASE TO BURN FOR THE FATHERLAND, 1918, GERMANY

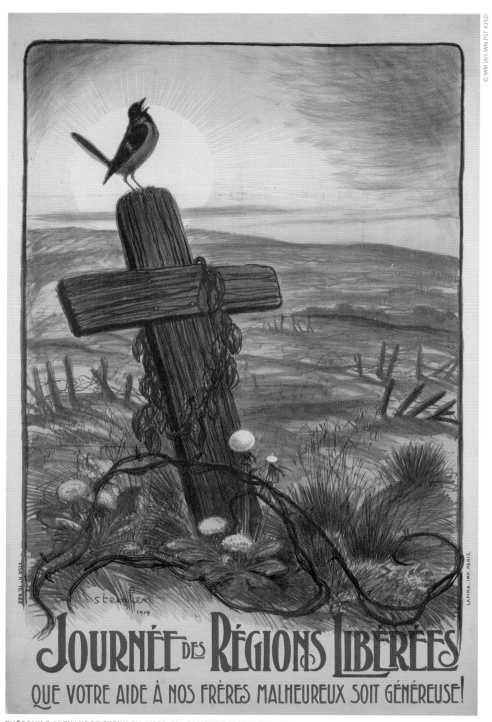

THÉOPHILE ALEXANDRE STEINLEN, LIBERATED REGIONS DAY, 1919, FRANCE

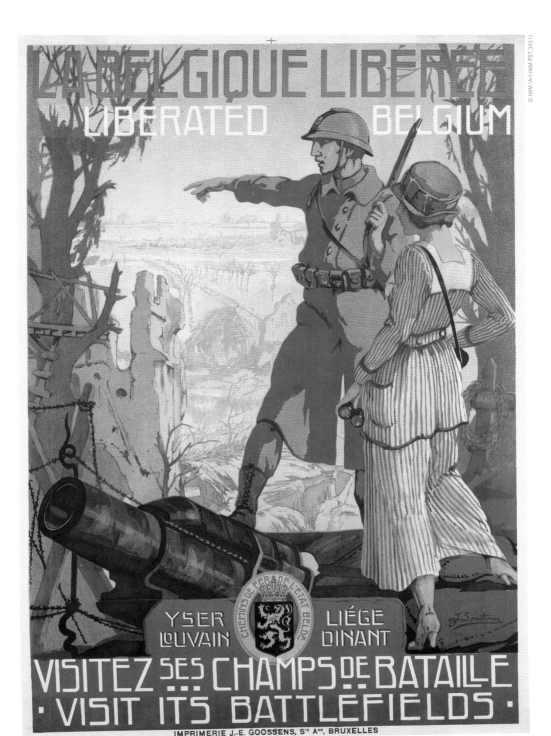

J SENTREIN, LIBERATED BELGIUM, 1919, BELGIUM